PARIS IN COLOR

Nichole Robertson

CHRONICLE BOOKS

SAN FRANCISCO

Library of Congress Cataloging-in-Publication Data
Robertson, Nichole.
 Paris in color / Nichole Robertson.
 p. cm.
 ISBN 978-1-4521-0594-9
1. Paris (France)—Pictorial works. 2. Color photography. 3. Color in art.
4. Photography, Artistic. I. Title.
 DC707.R595 2012
 914.4'36100222—dc23

 2011027742

Manufactured in China

Designed by Ayako Akazawa

10 9 8 7 6 5 4

Chronicle Books LLC
680 Second Street
San Francisco, California 94107
www.chroniclebooks.com

DEDICATION

For Evan, Alexander, and Liam.

INTRODUCTION

Did you ever have the nagging sense that you weren't living the life you should be living? In the fall of 2008, I did. And rather than continue to ignore it, I posed the following question to my husband, Evan:

"Want to move to Paris?"

To my surprise, he answered, "Hell yes. Let's go."

So why Paris? Quite simply, it was our touchstone for happiness—happiness that didn't relate to getting ahead or conspicuous consumption—things like preserved culture, heavenly light, ubiquitous beauty, celebration of wit, and a seemingly universal acceptance of working to live. This was our perspective from the outside looking in, and we didn't care at the time if these things were clichés. We believed it, and we wanted it.

When we arrived in January of 2009, the winter clouds extended the typical muted grays and whites of Paris's streets and Hauss-mann buildings across the entire sky. The whole city was a perfect, neutral palette against which anything could happen. We had our fresh start.

Nothing sharpens your senses like a new address. The streets were no longer an obstacle course to run. We walked for pleasure, with no agenda and with no particular destination in mind. We noticed details, and took time to take them in. For recovering New Yorkers, nothing could have inspired us more.

Although we didn't know it at the time, we were cultivating what the French call flânerie. Like Baudelaire, the flâneur wanders the streets for exploratory pleasure with no destination to distract him from the city's curiosities. Back in the mid-1800s, it actually became fashionable to walk a pet turtle to set a slow pace. We didn't have a turtle, but we did have two young children—in many respects not dissimilar.

As we strolled, the objects that attracted my eye were café chairs, coffee cups, flowers, graffiti, doors, and chalkboards—things meant to be touched, shared, enjoyed, and worn down. On one of the first occasions that I photographed a chair, a nearby Parisian gentleman looked confused and a bit annoyed. "Mais pourquoi? C'est une chaise." ("But why? It's a chair.")

It may sound silly, but the chair was everything I had come here for. I spent a decade sitting in office chairs and staring at computer screens. Some of my colleagues dreamed of scoring one of the nicer chairs on one of the higher floors, but I longed for light that wasn't fluorescent and life that wasn't scheduled.

And now here it was. The chair I wanted—the kind of chair where people had conversations worth having, thoughts worth pondering, and views worth taking in. I took a photo to remember the moment. The chair was the first of many everyday objects that I would photograph and cherish.

On our long walks, one particular object would strike me—a bright blue moped, for example—and I'd obsess about that color for the rest of the day. Focusing on only one color allowed me to see things I might have otherwise overlooked, like a door handle or an interesting pattern in chipped paint. I suppose I missed quite a few orange things that day, but details are like that: you need to favor them, or they won't reveal themselves. Each colorful detail popped against the natural textures of the beautiful, worn buildings as if waiting to be noticed. Some were out in the open. Others were well concealed from casual passers-by. Those were the best discoveries.

When I began posting photos from my walks on my blog, the response was overwhelming. Coming home with photos became something akin to coming home with a box of pastries, and I was eager to share them with friends. Every time I posted a collection of photos curated by color, my readers wanted more. Since I was quickly becoming obsessed, I was happy to oblige. When they asked me to sell prints of the photos, I was surprised, as I didn't consider what I was doing to be Photography with a capital P; it was simply a record of happiness. But their enthusiasm and vicarious enjoyment gave me the inspiration to see through what would ultimately become a two-year project. I am grateful to them for their support, and this book is dedicated to them.

Paris taught me a lot of things; most important among them is to take my time. Flânerie requires curiosity, patience, and open eyes. I hope that these photos inspire you to put down your preoccupations as well, at least for a little while, so that you can find as much happiness in viewing them as I did in discovering them.

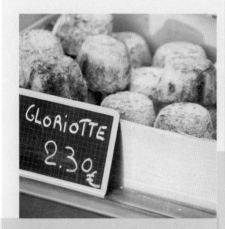

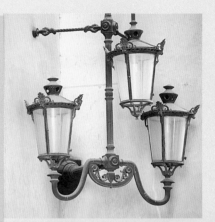

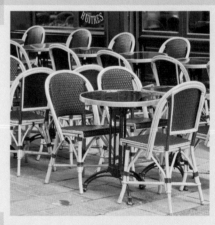

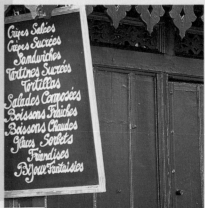

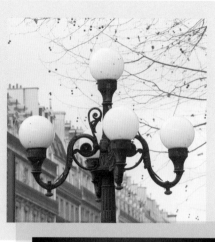
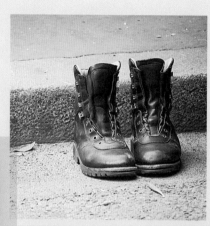

NOIR

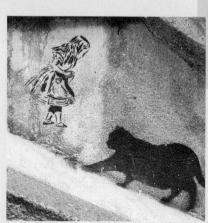

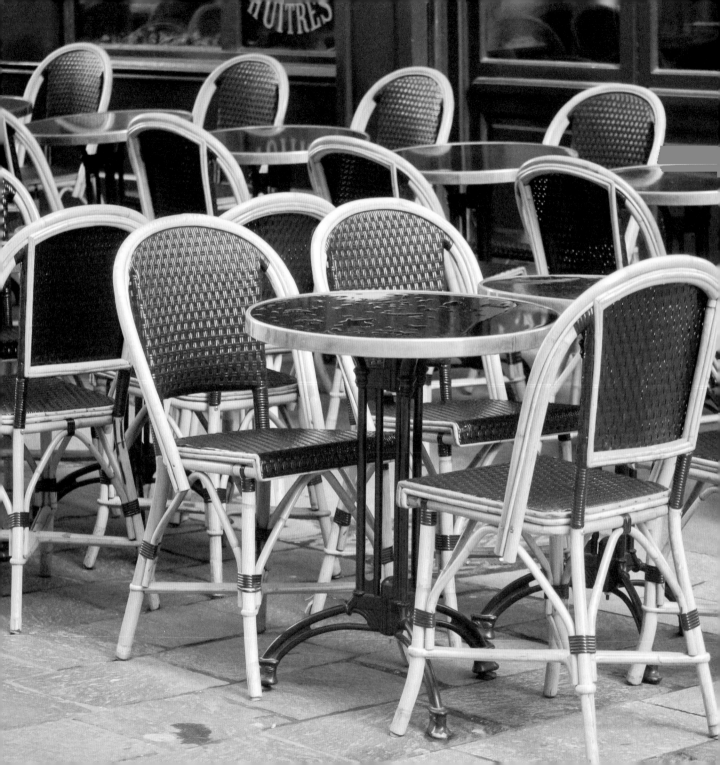

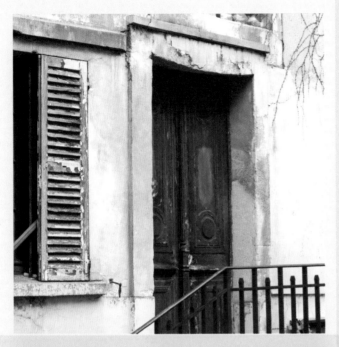

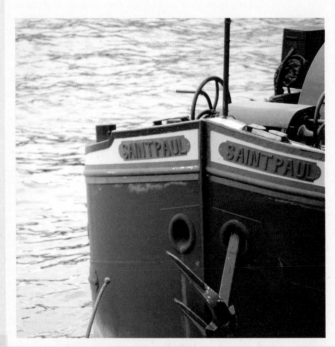

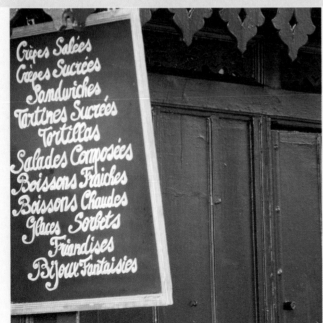

Crêpes Salées
Crêpes Sucrées
Sandwiches
Tartines Sucrées
Tortillas
Salades Composées
Boissons Fraiches
Boissons Chaudes
Glaces Sorbets
Friandises
Bijoux Fantaisies

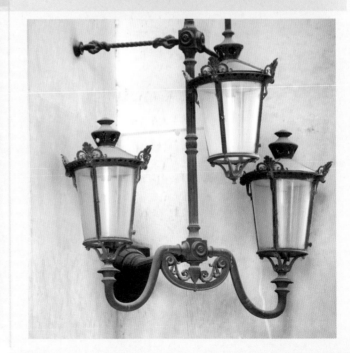

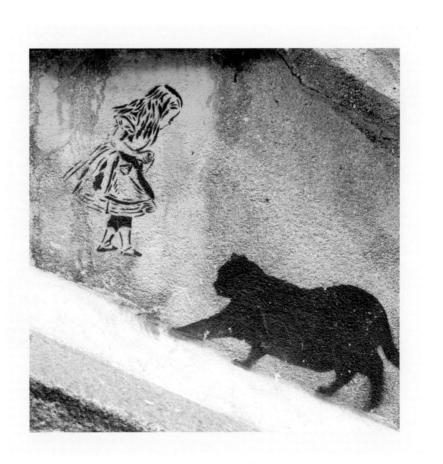

ÉTONNEZ VOS INVITÉS...

- Toast de Magret fumé
- Salade Craquante
- Poivron Farci au Confit de Canard
- Glace au Foie Gras

CONCOURS 2010
GENERAL AGRICOLE

2 MEDAILLES D'OR

2 MEDAILLES DE BRONZE

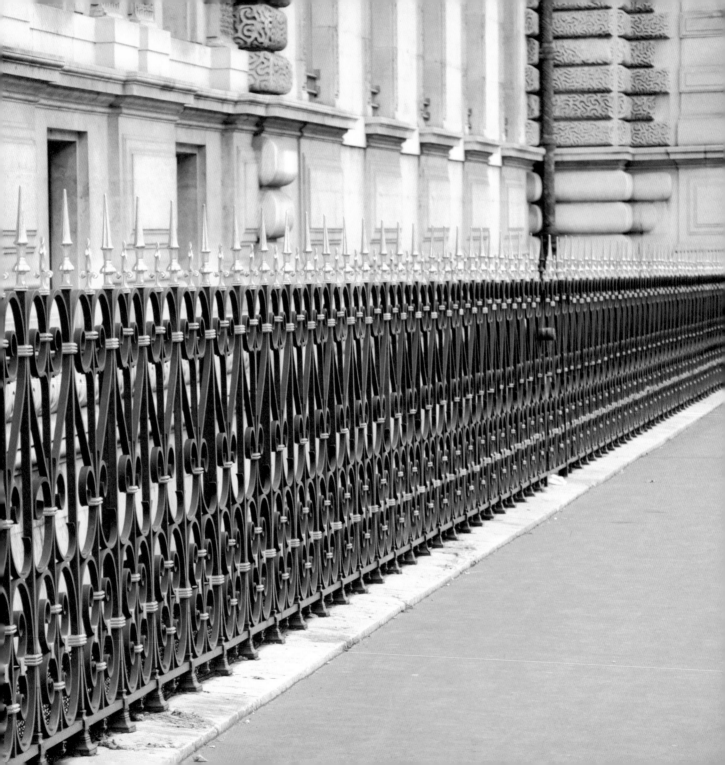

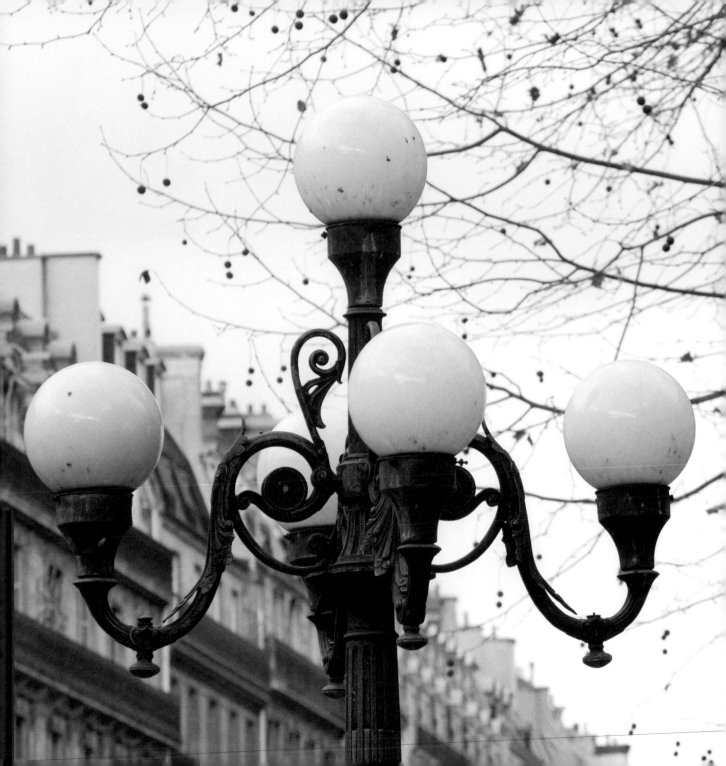

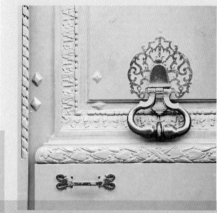

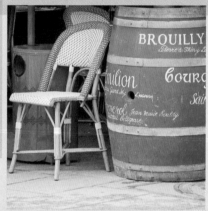

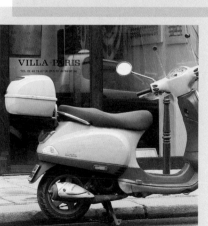

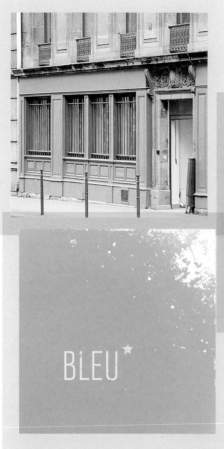

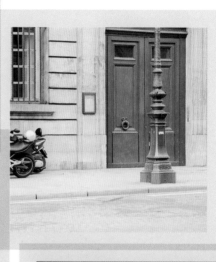

BLEU ✦

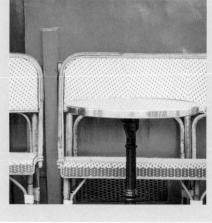

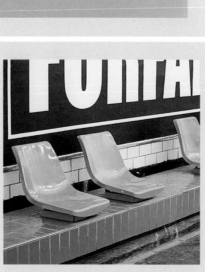

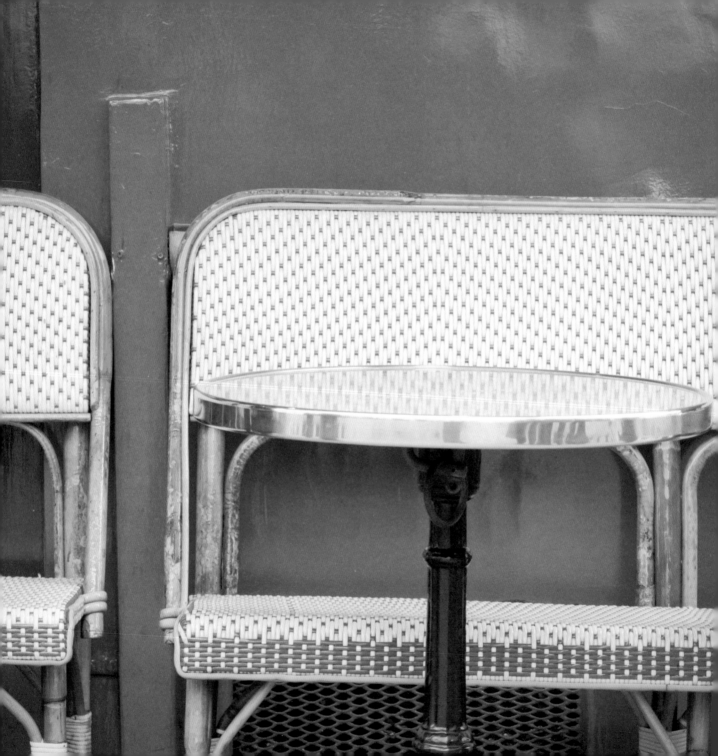

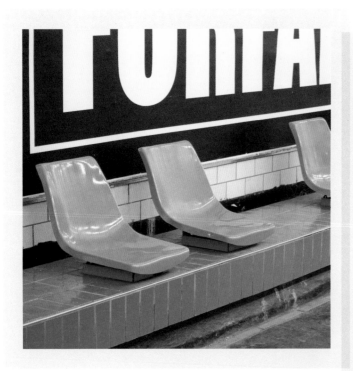

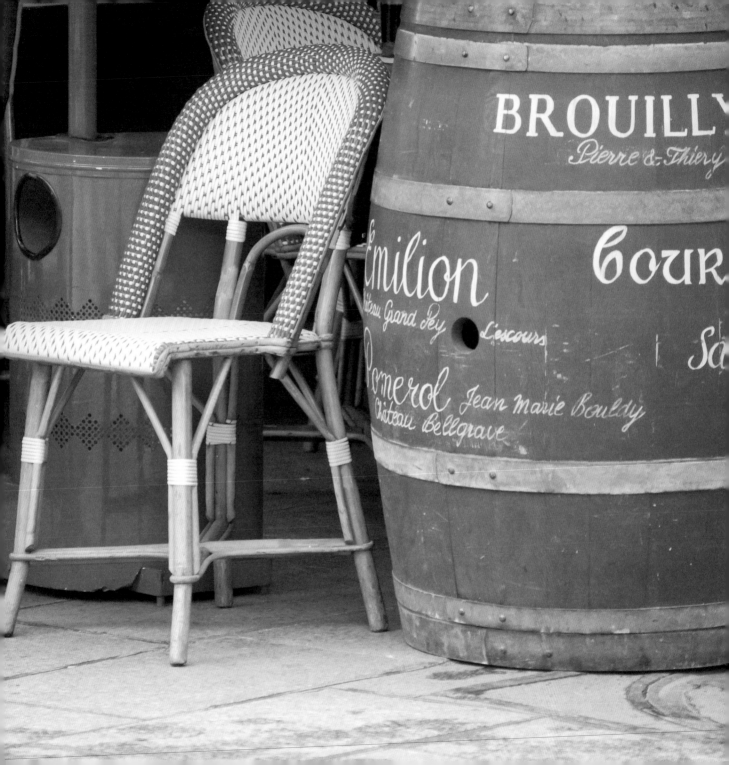

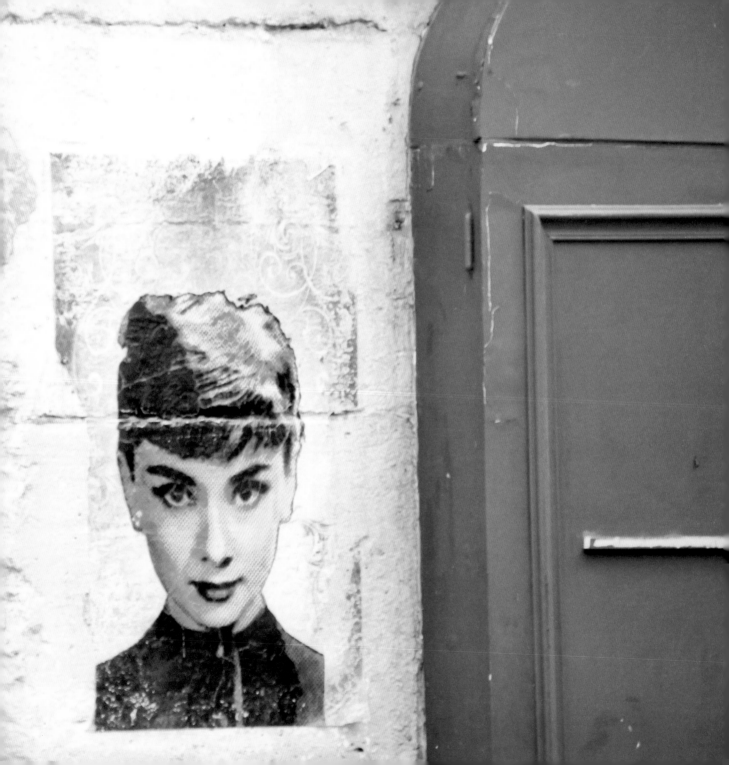

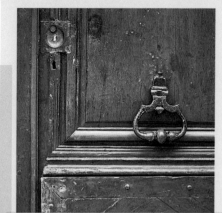
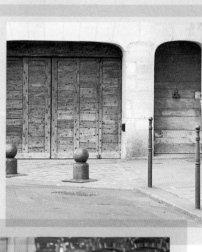
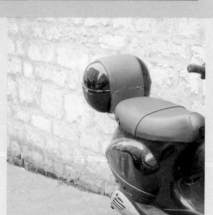

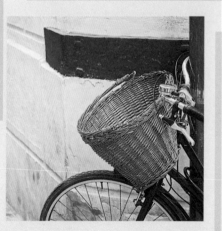
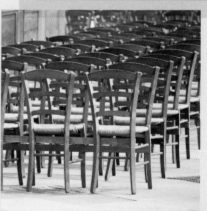

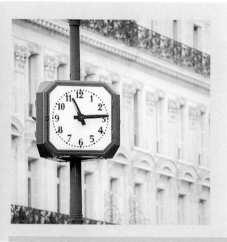

MARRON

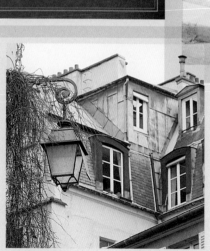

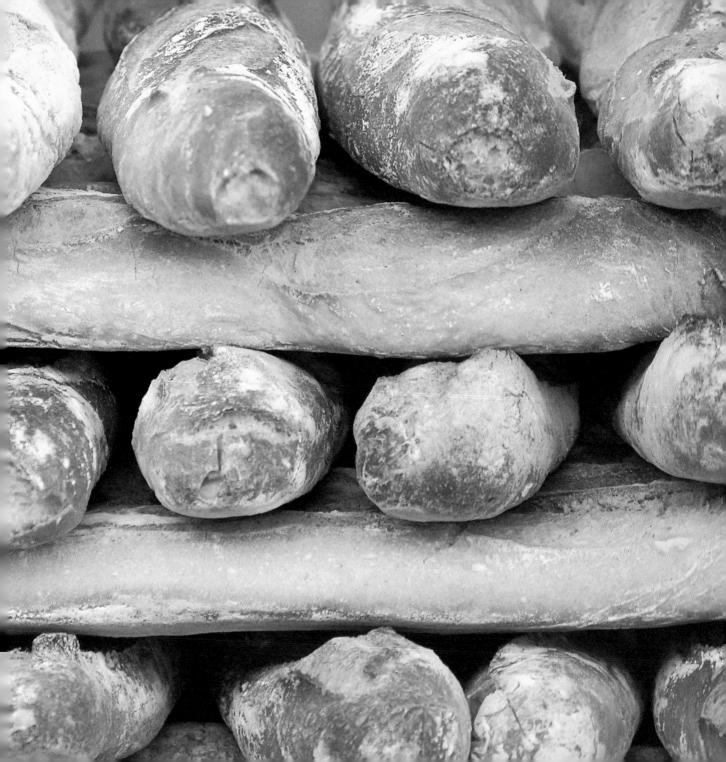

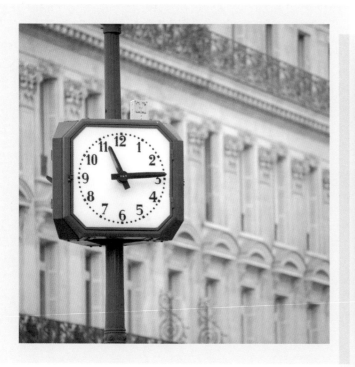
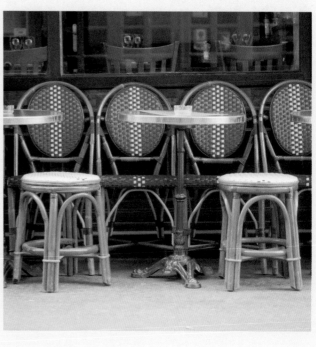

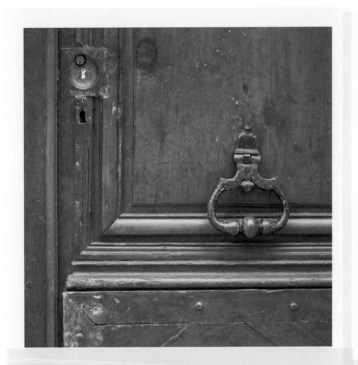

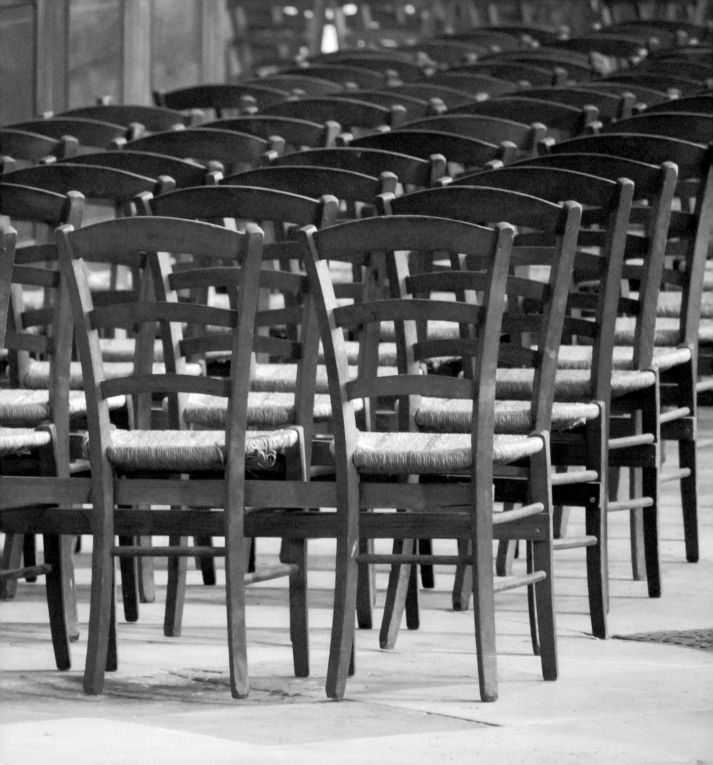

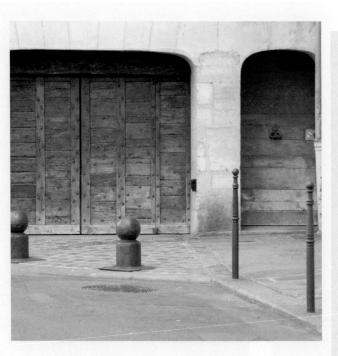
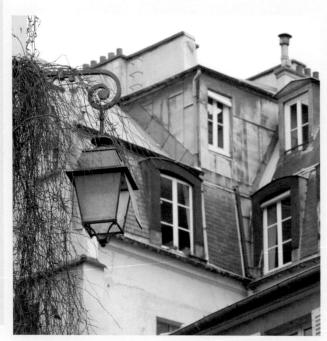

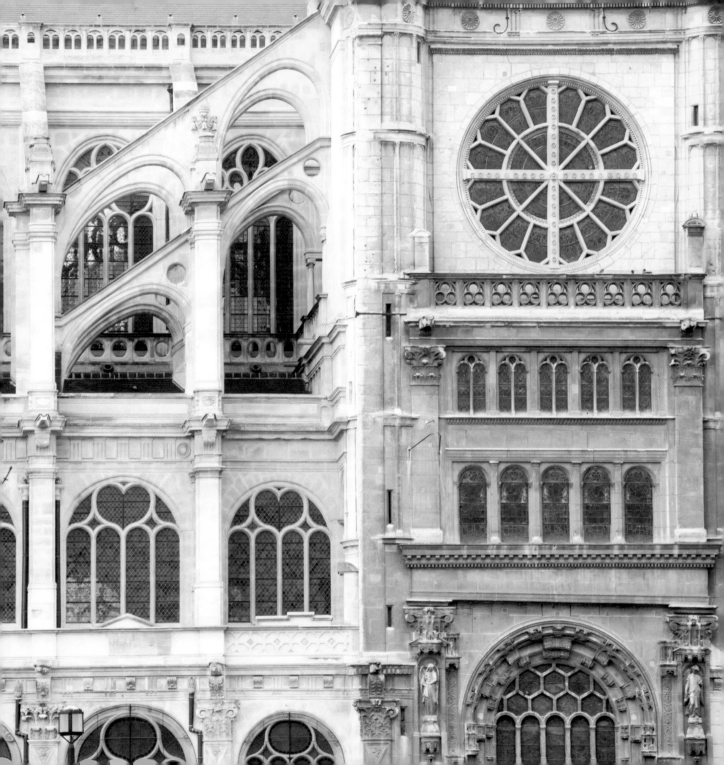

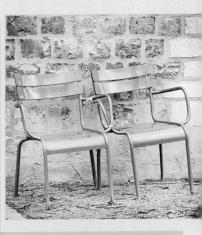

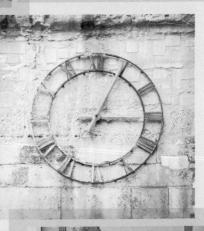

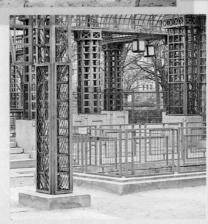

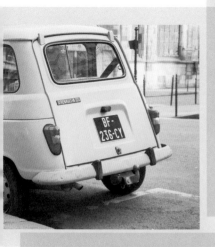
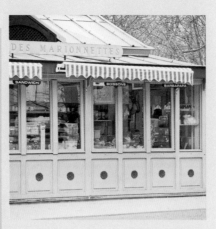
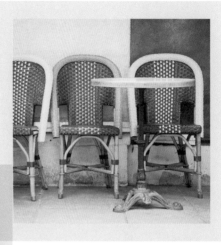

VERT

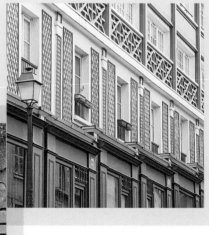
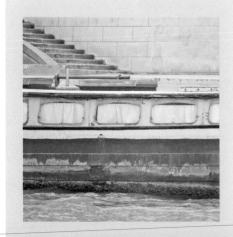
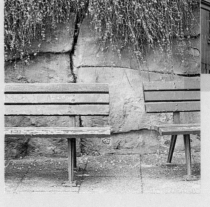

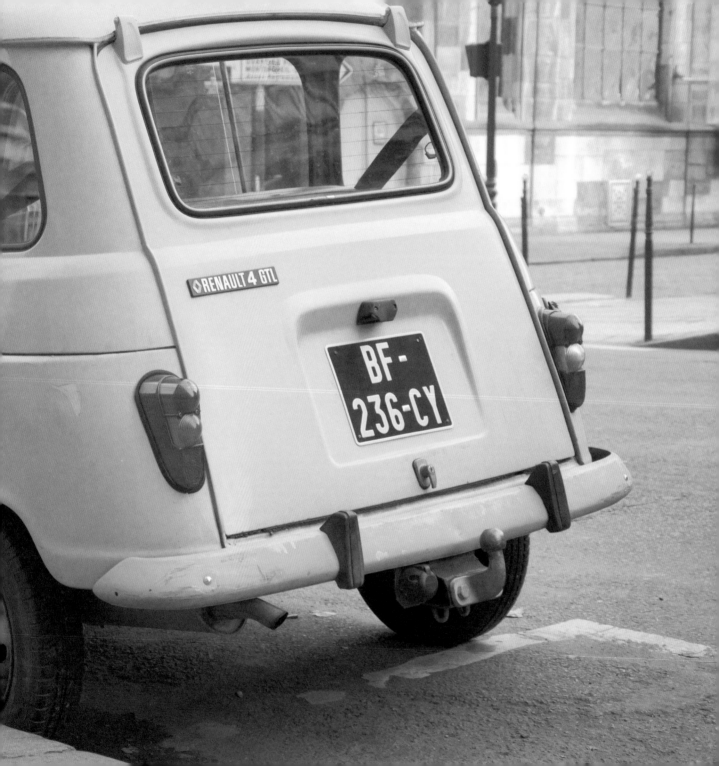

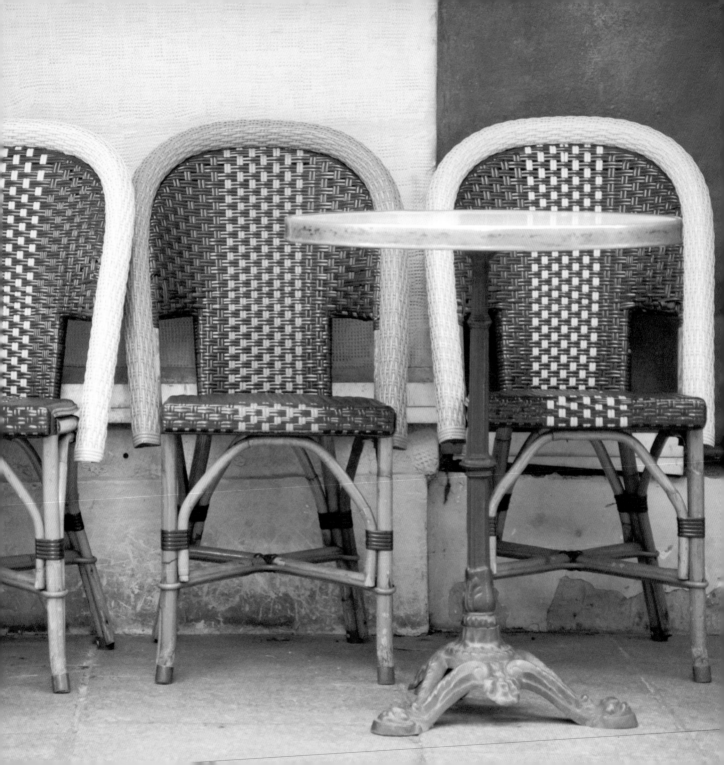

OES MARIONNETTES

SANDWICH

BOISSONS

BARBAPAPA

BARBAPAPA

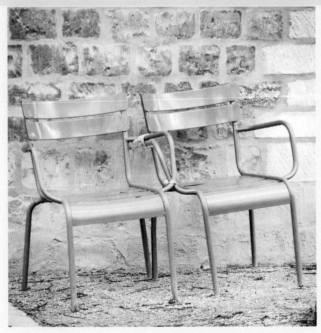
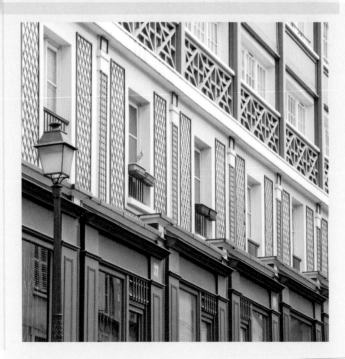

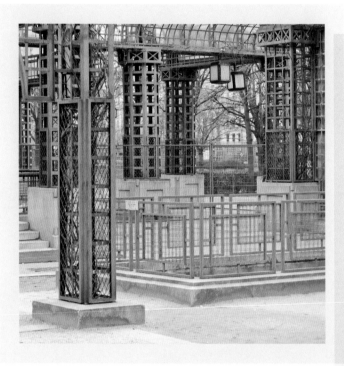
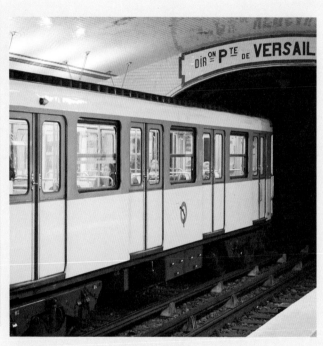

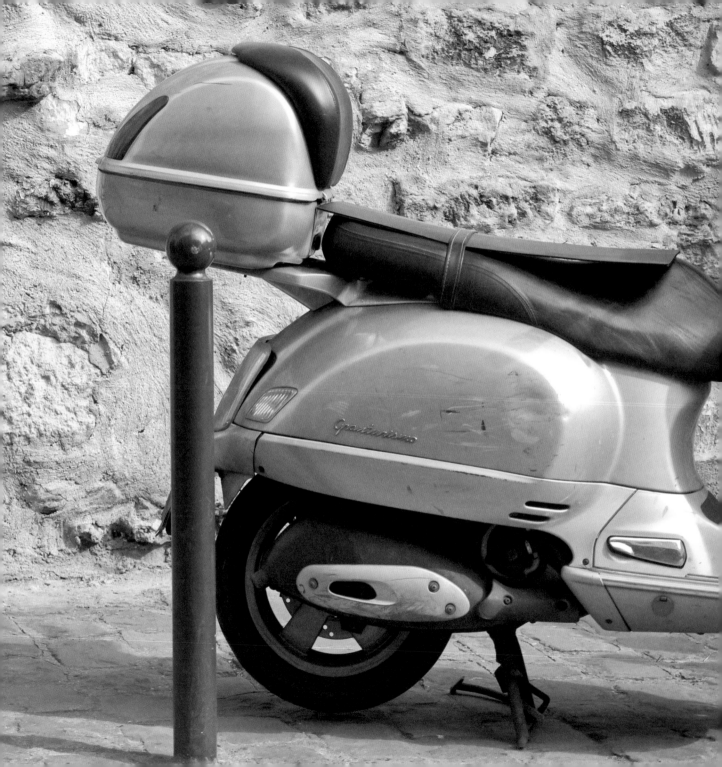

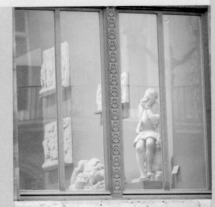
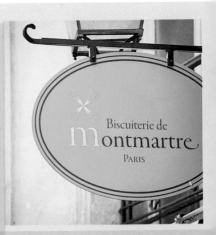

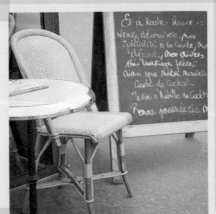
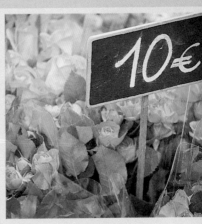
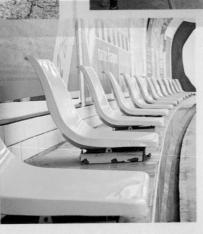
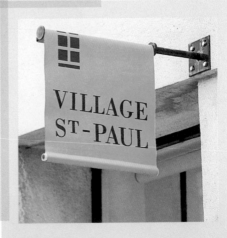

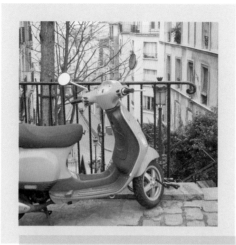

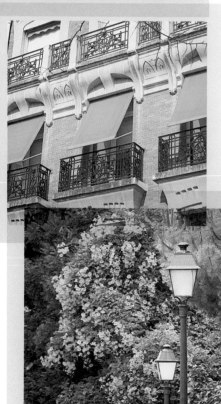

Orange

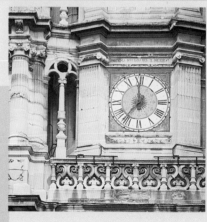

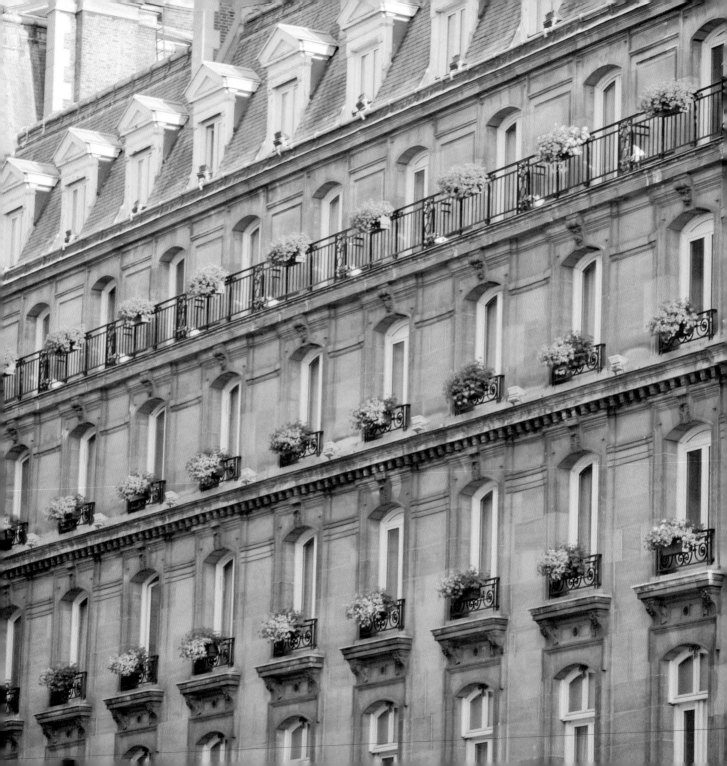

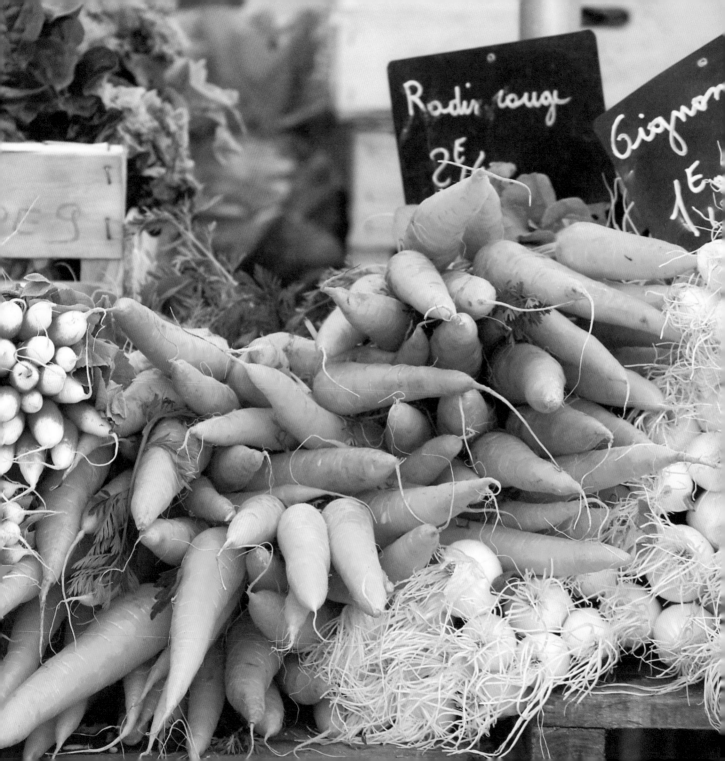

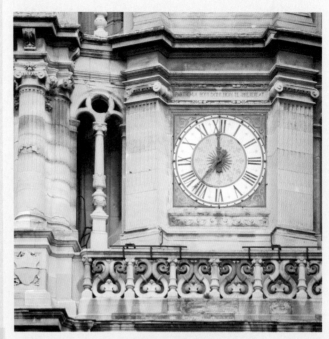

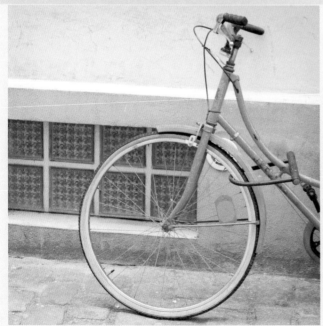

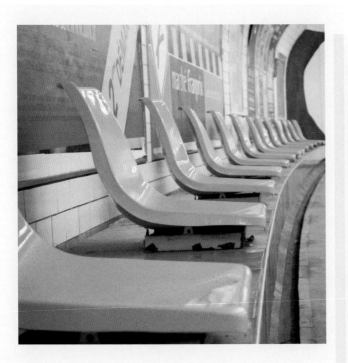

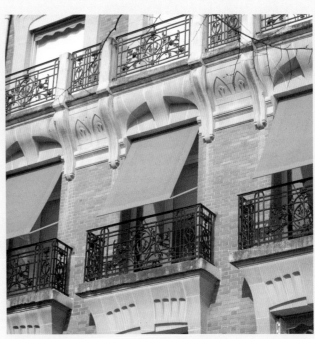

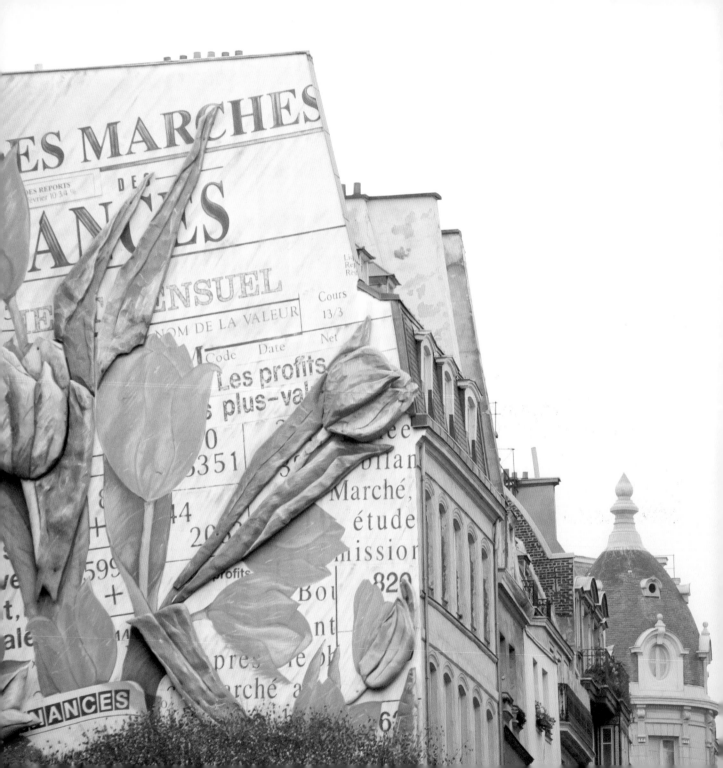

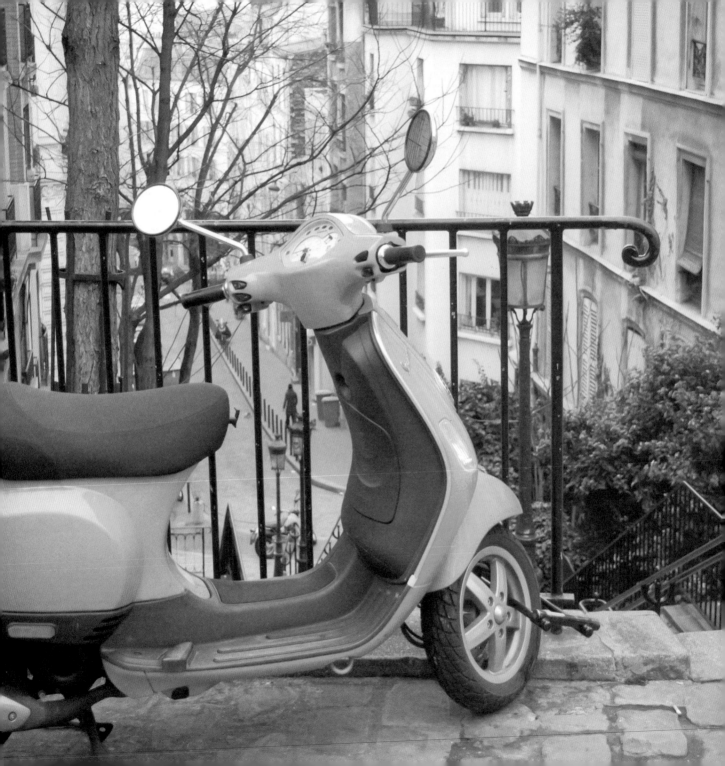

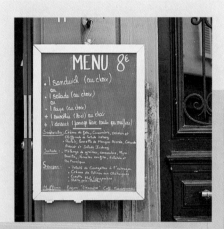

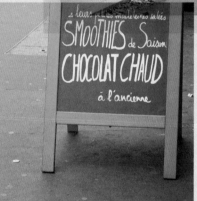

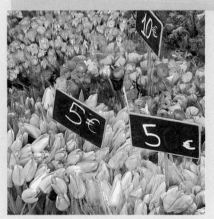

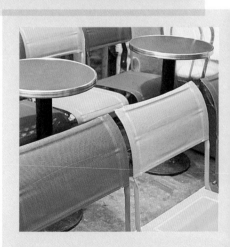

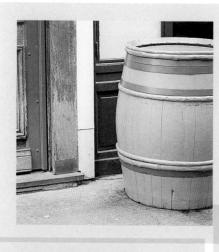
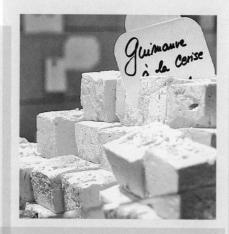
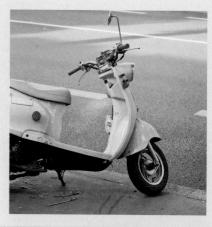

R·O·S·E

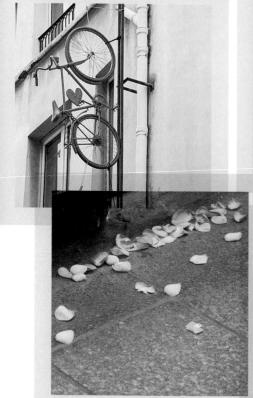
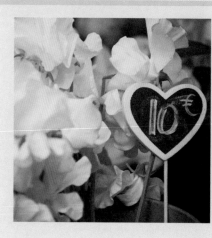
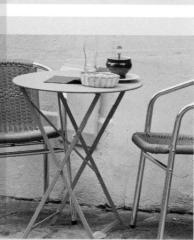

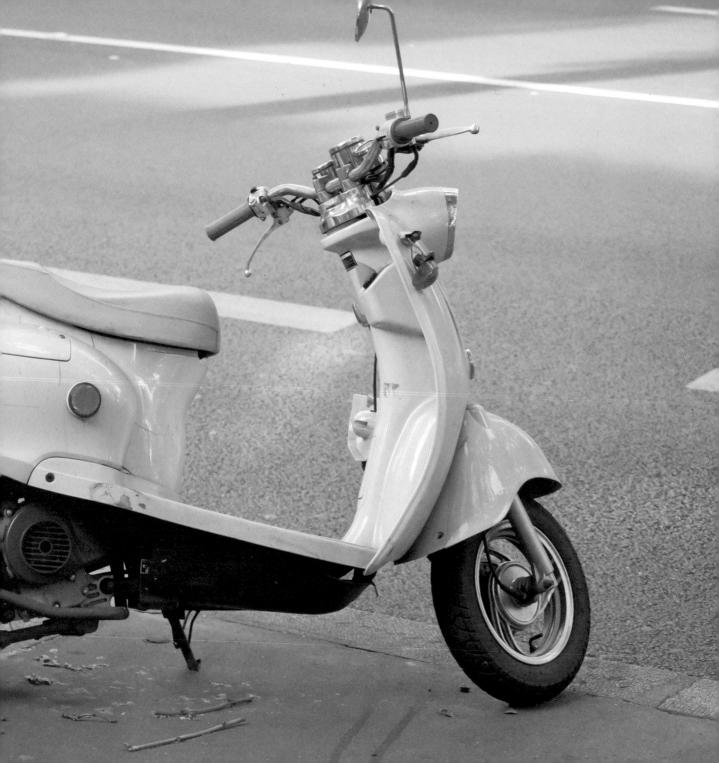

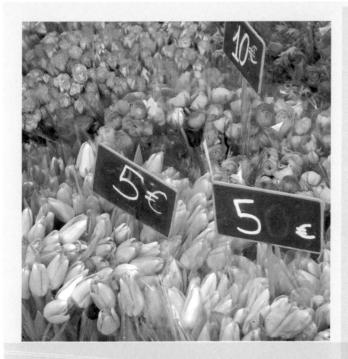

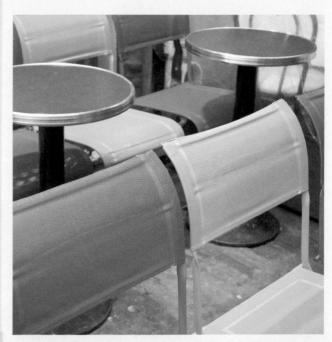

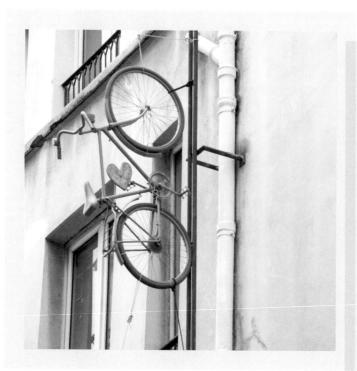

...leurs petites madeleines salées

SMOOTHIES de Saison

CHOCOLAT CHAUD

à l'ancienne

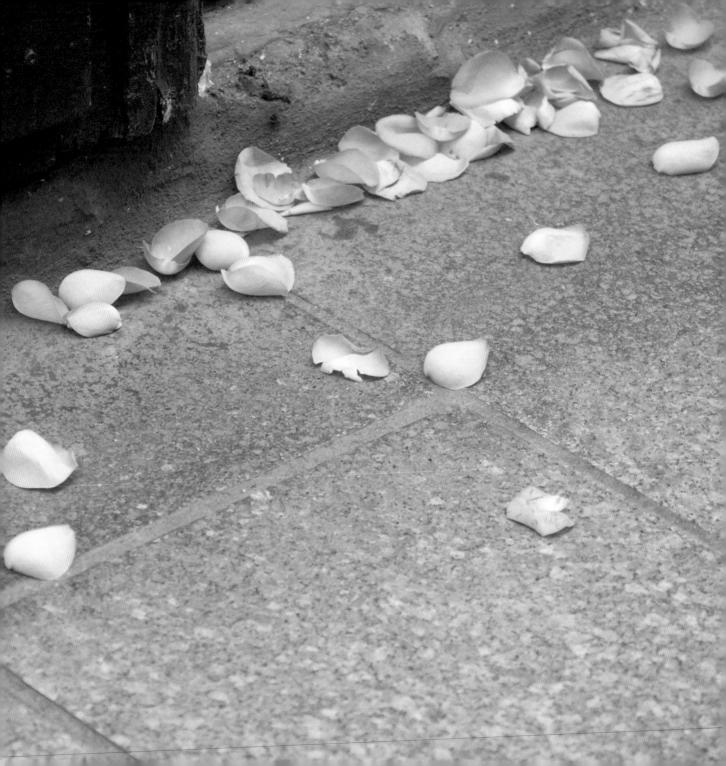

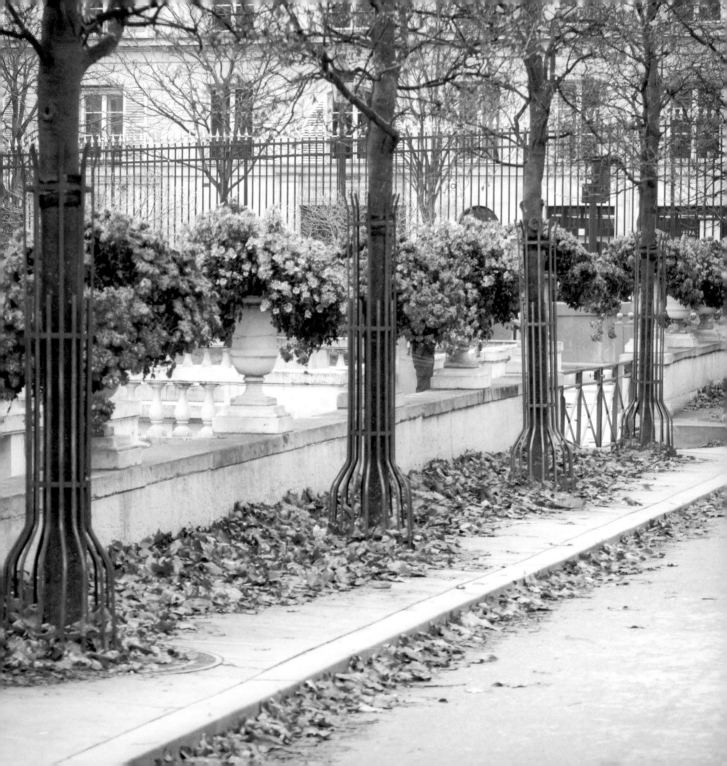

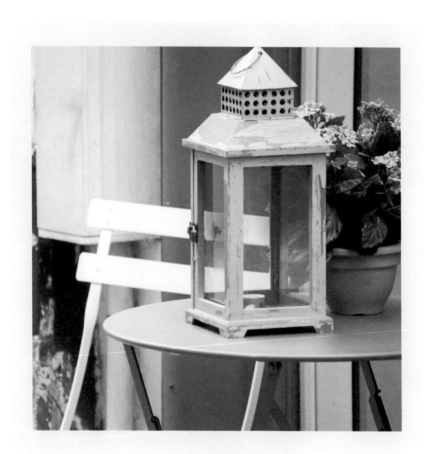

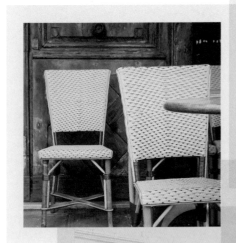

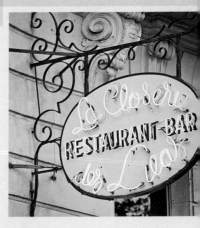

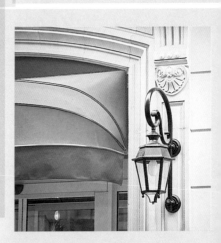

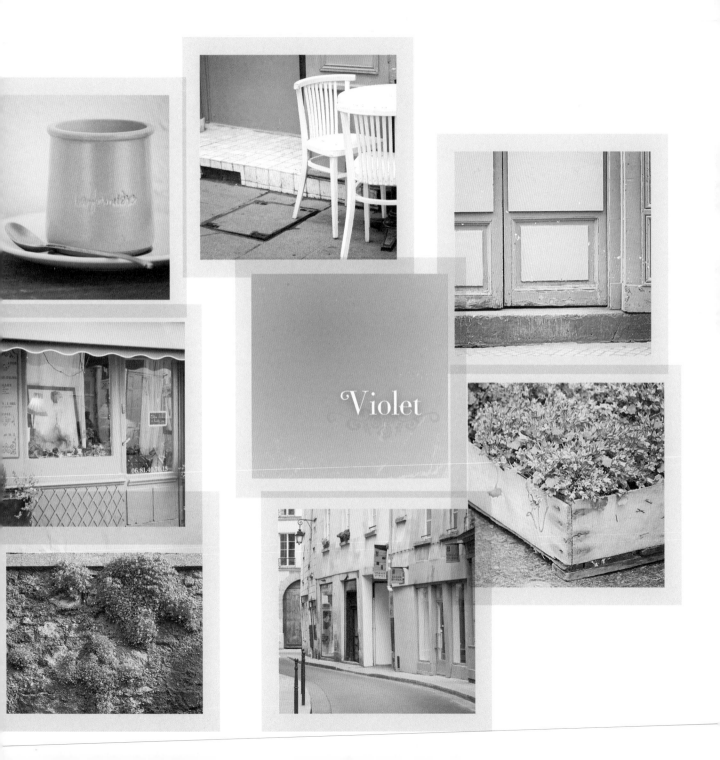

Violet

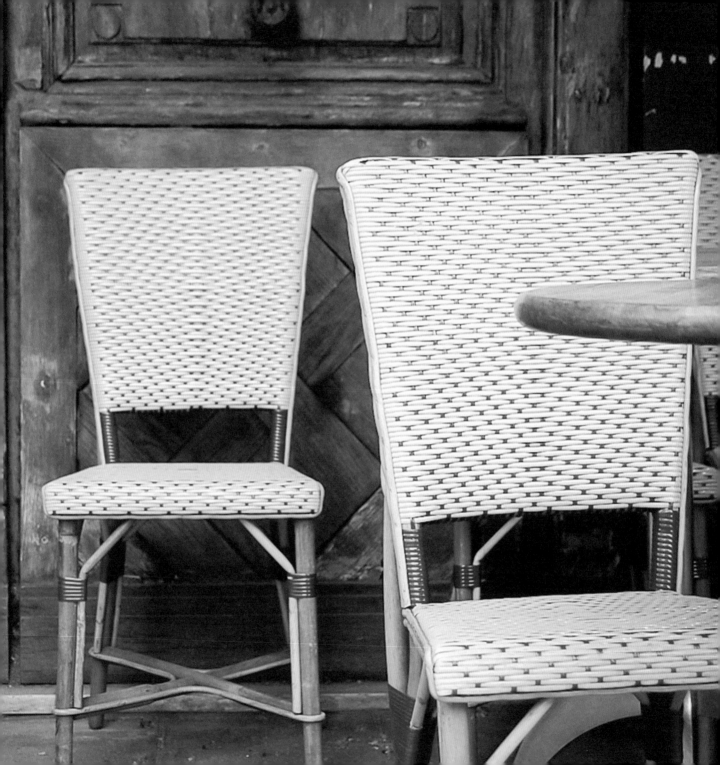

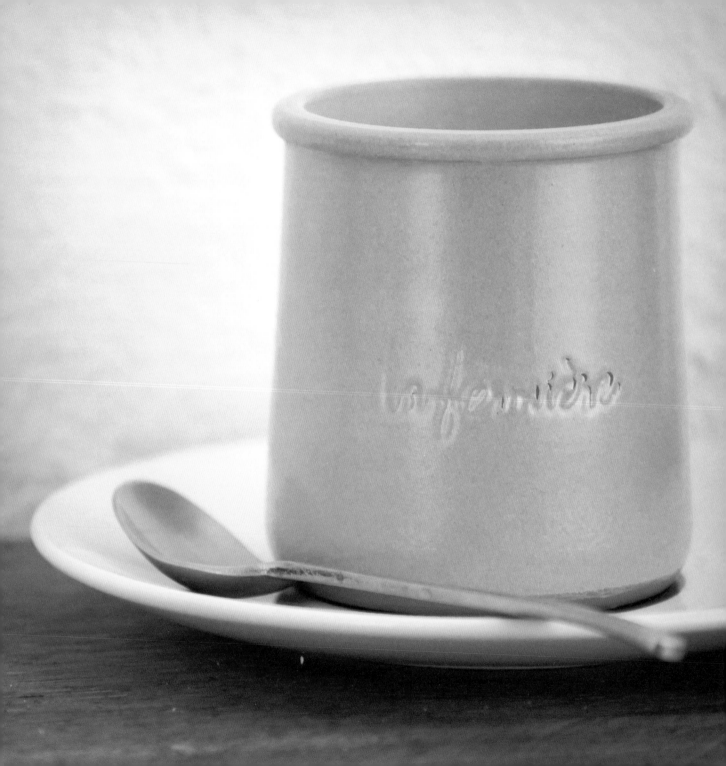

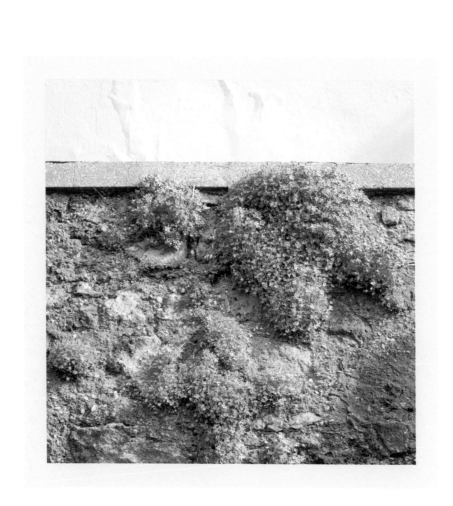

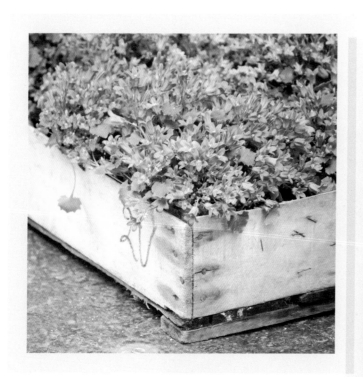

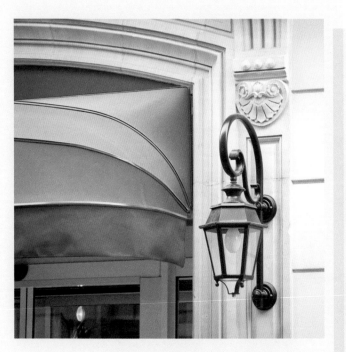
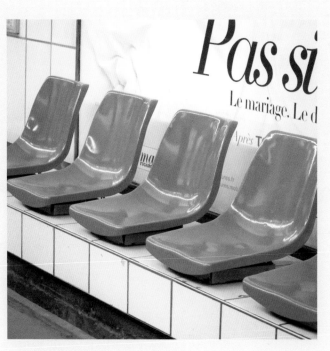

BOUTIQUE - ATELIER

TABLEAUX
.huile
.aquarelle
.encre
.acrylique

TROMPE L'OEIL
sur commande

· PATINE ·
.sur murs.
.sur meubles.
.sur objets.

DÉCOR de THÉÂTRE

violette

La Closerie
RESTAURANT-BAR
des Lilas

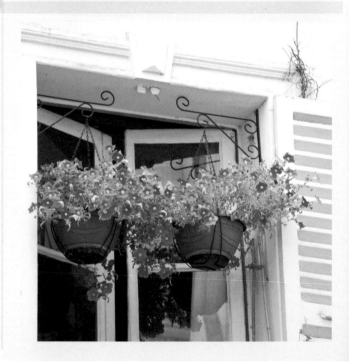

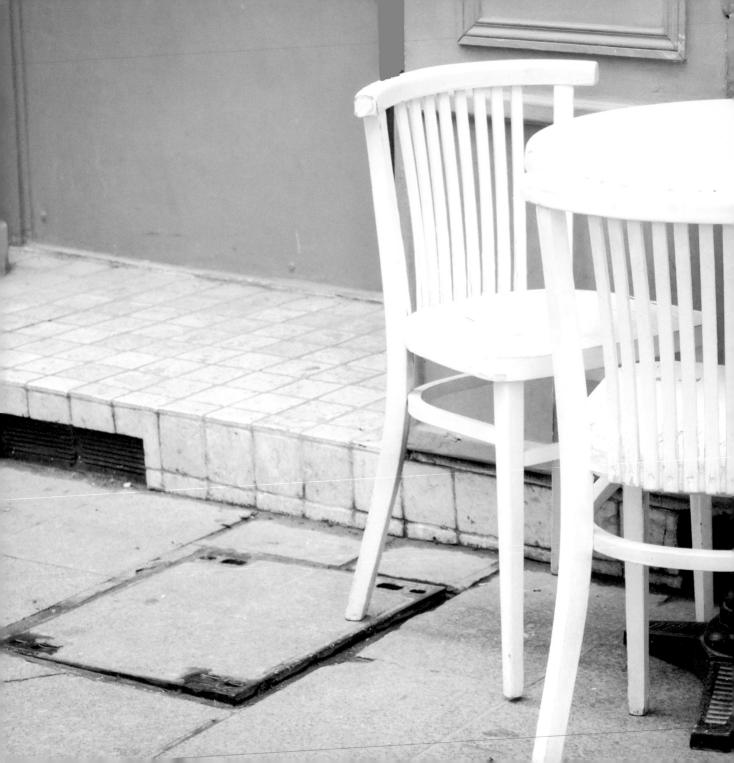

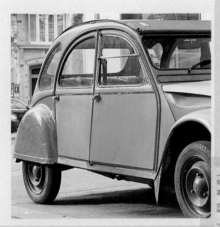
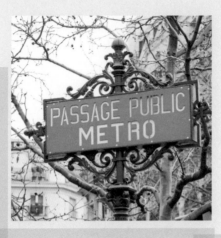
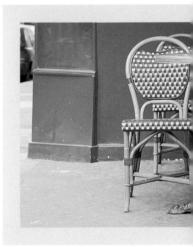
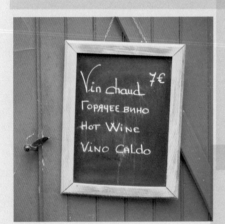
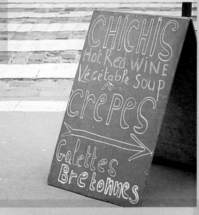
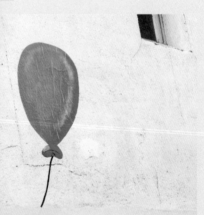
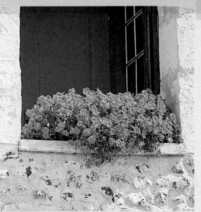
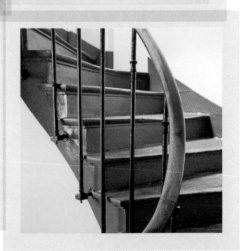

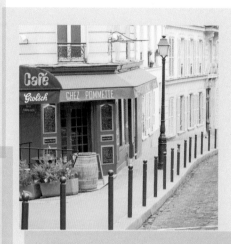

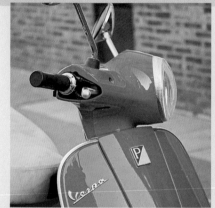

ROUGE

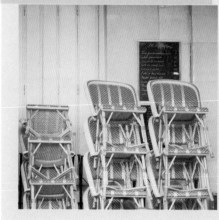

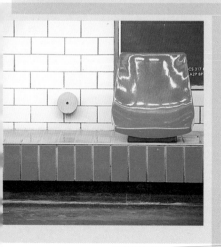

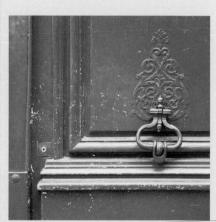

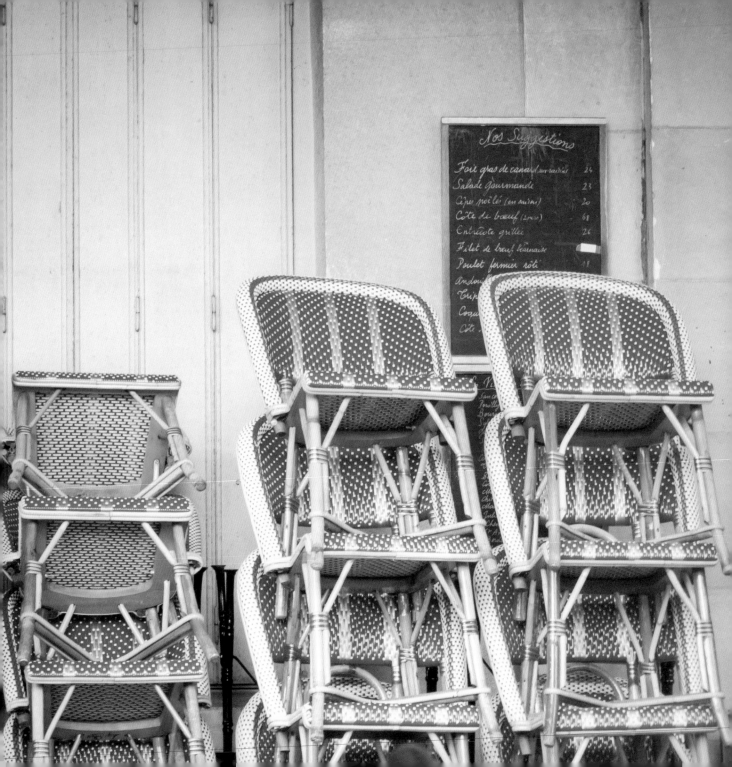

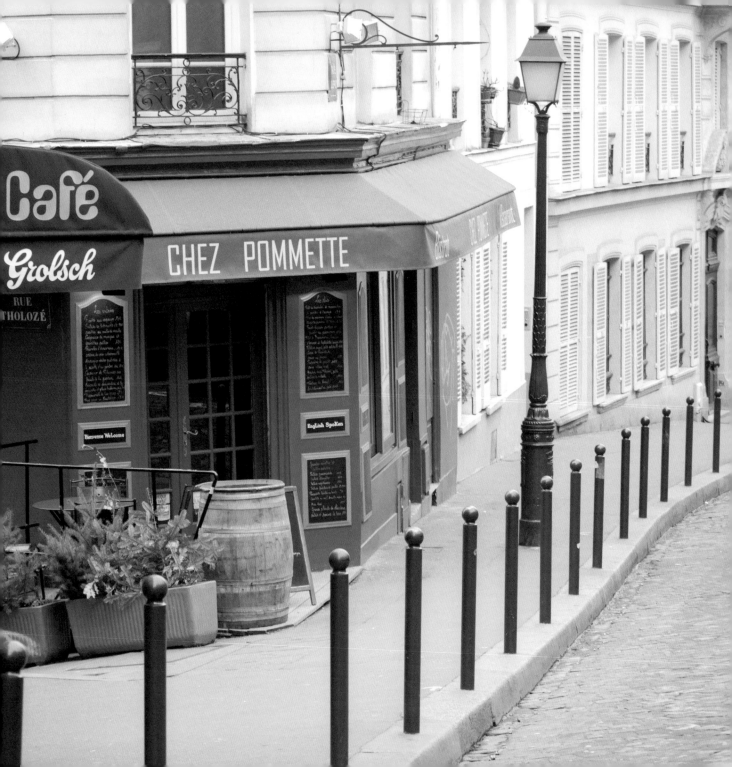

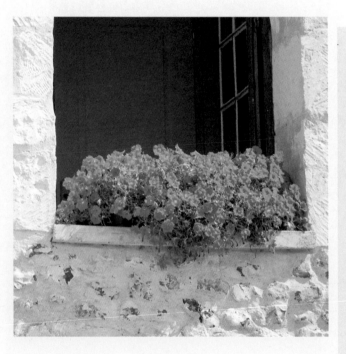
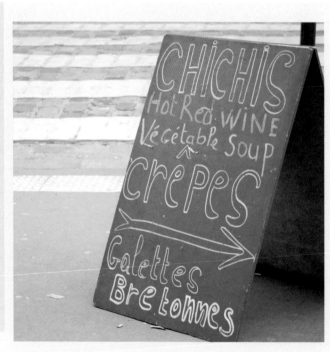

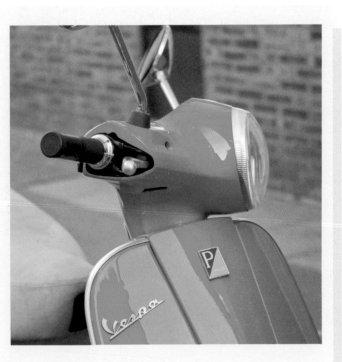

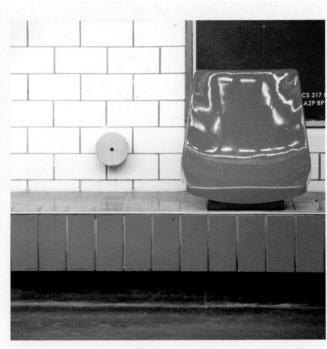

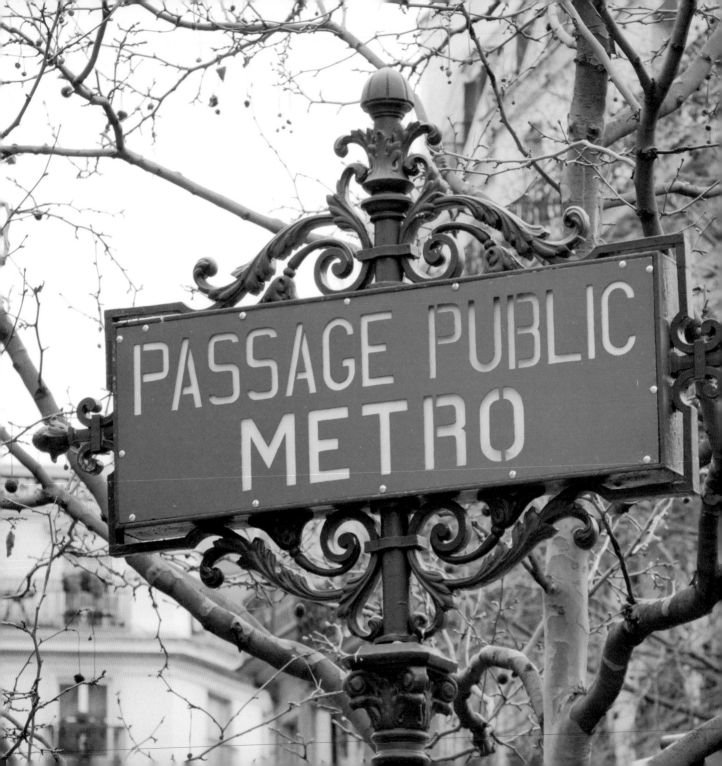

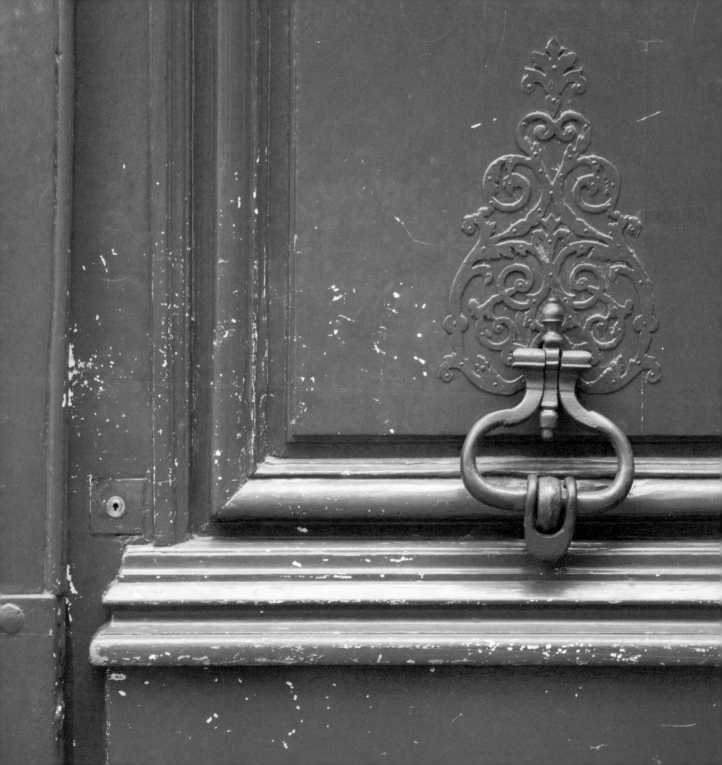

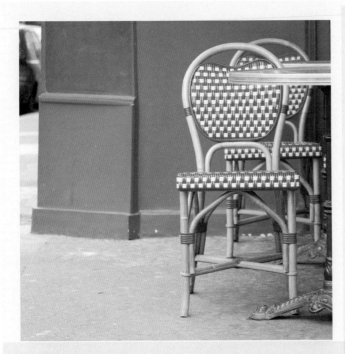

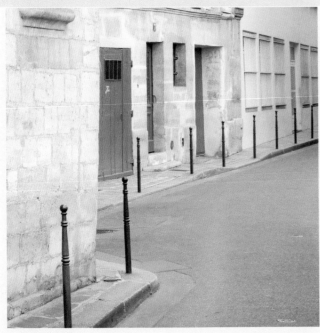

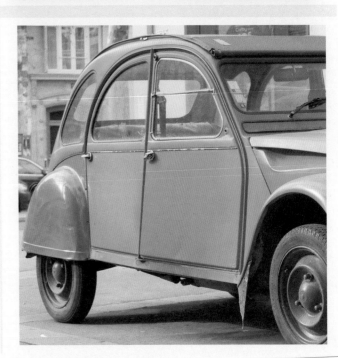

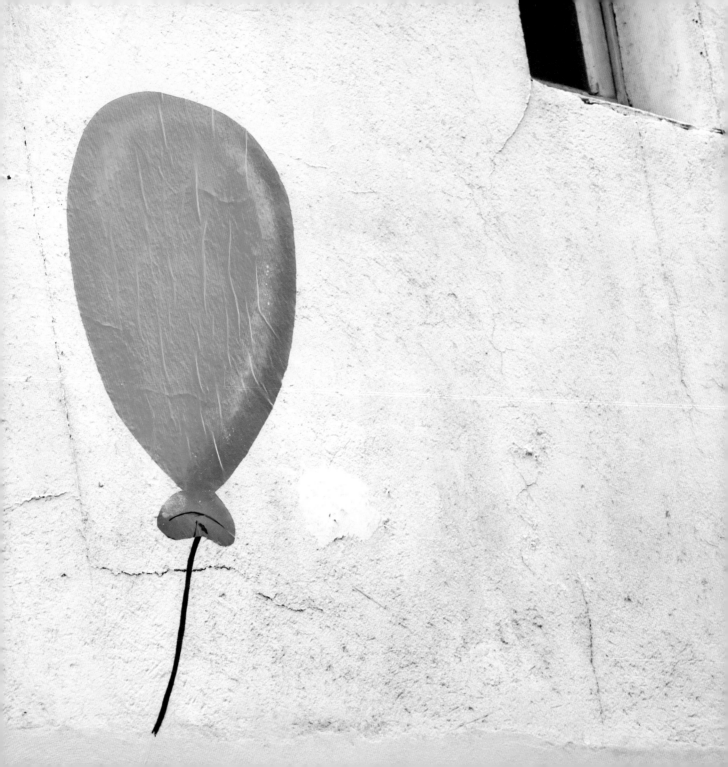

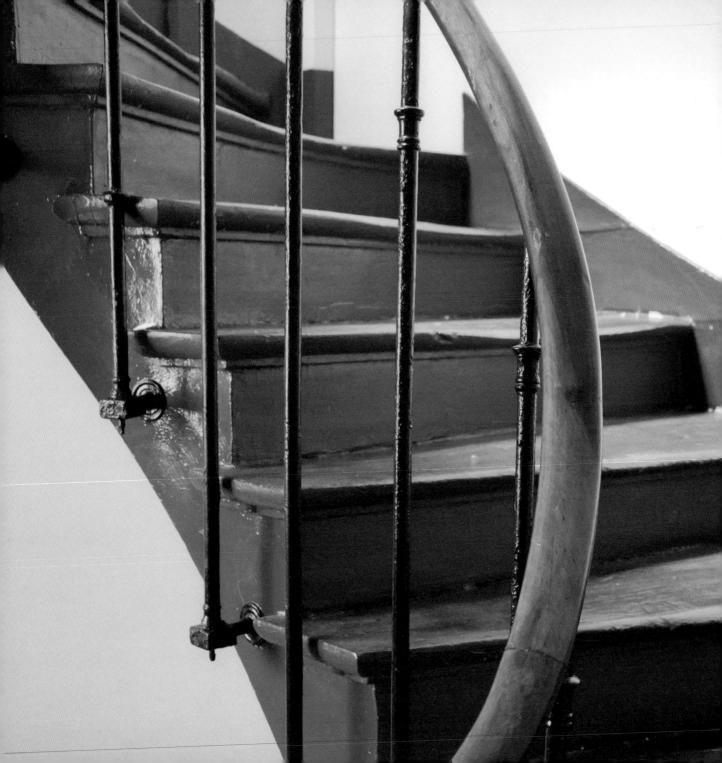

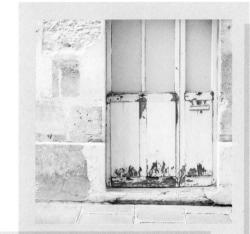
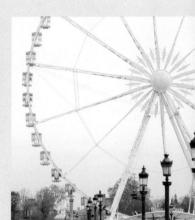

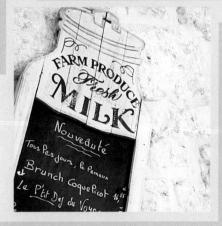

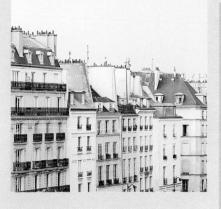

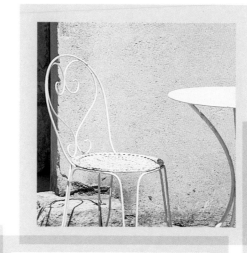

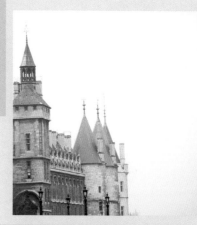

BLANC

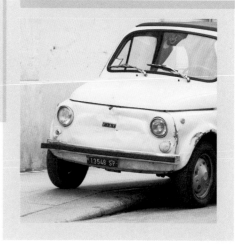

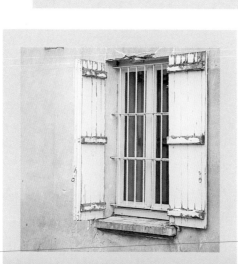

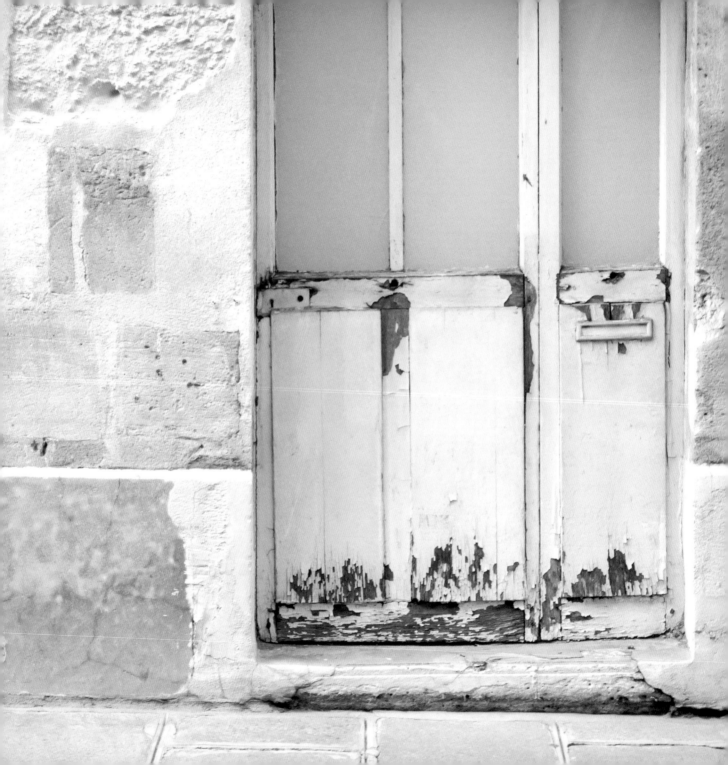

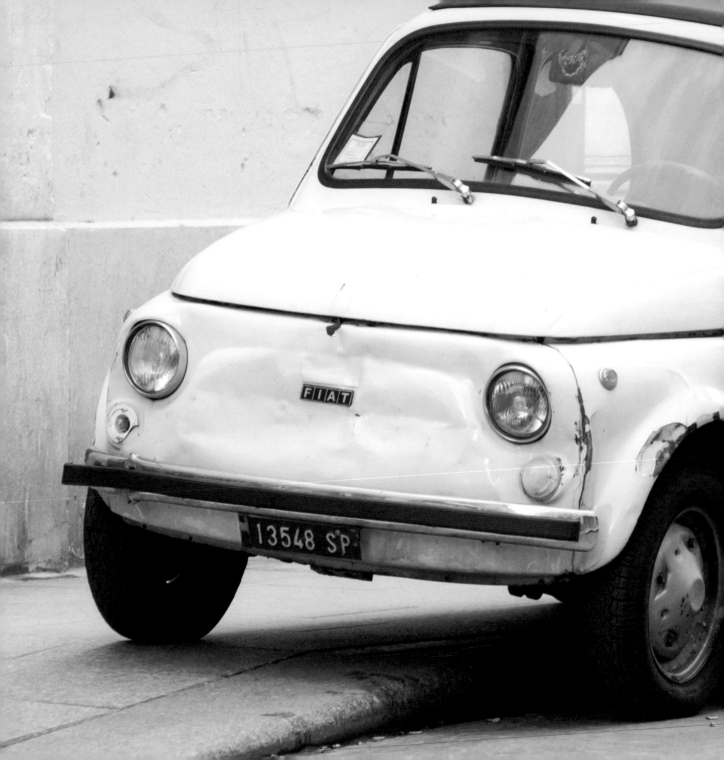

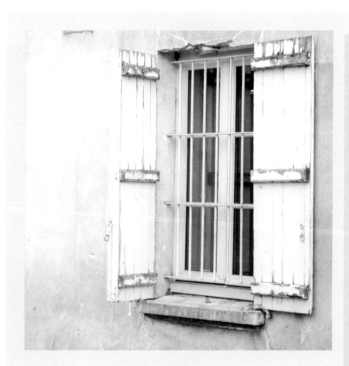
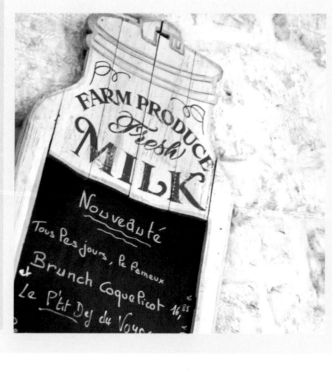

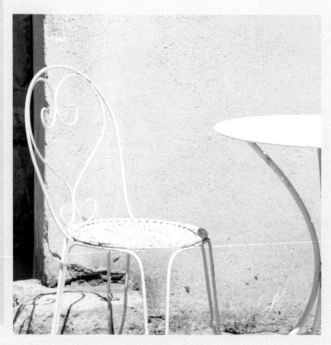

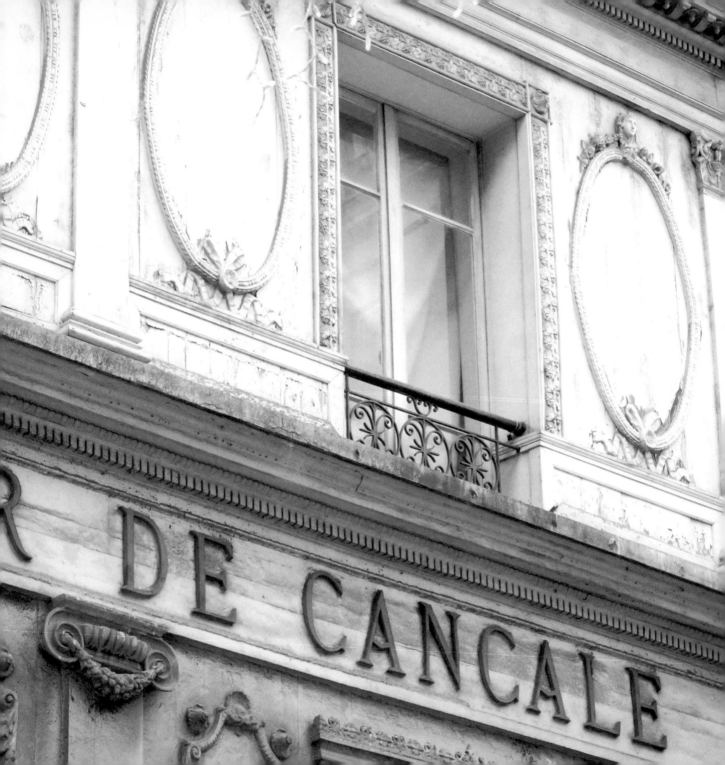

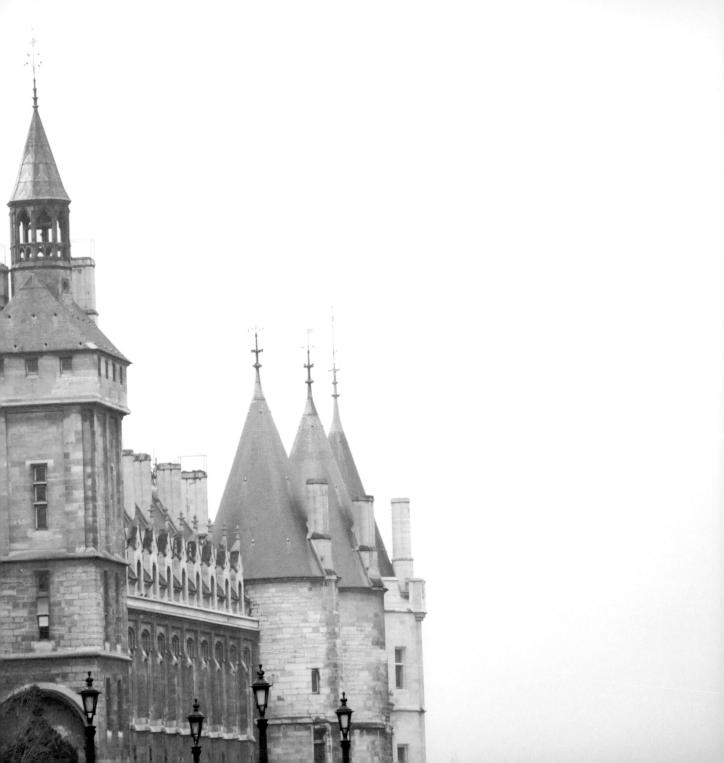

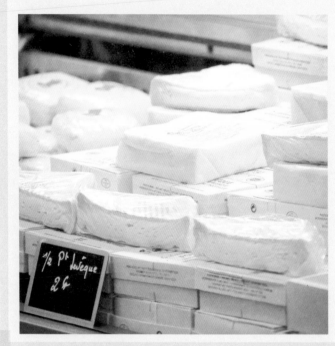

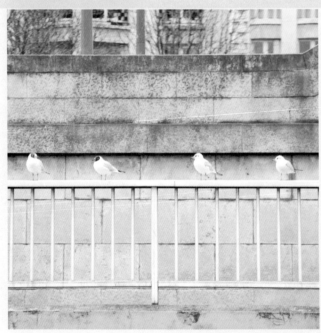

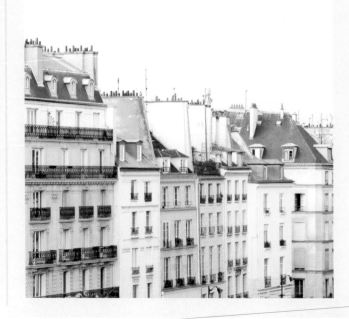

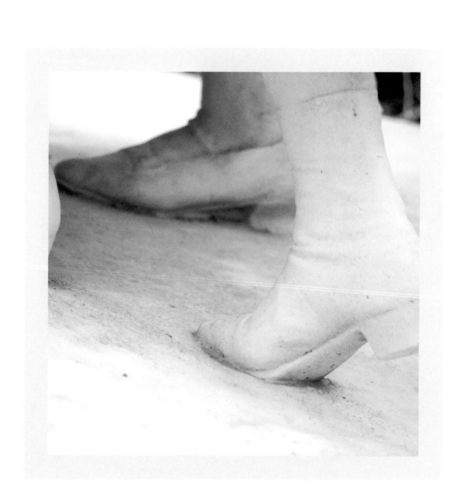

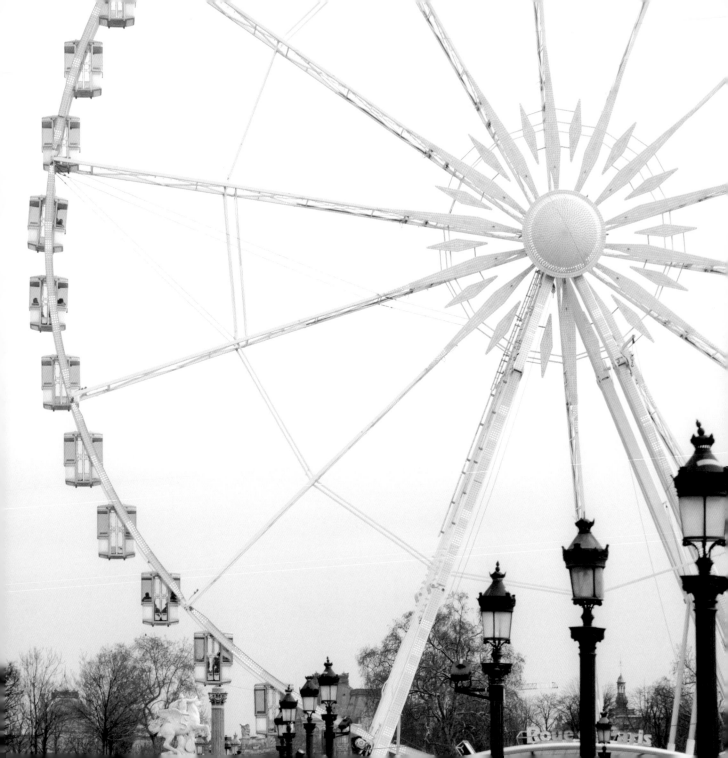

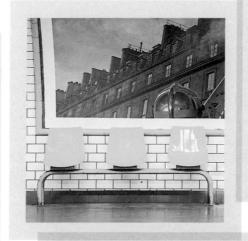
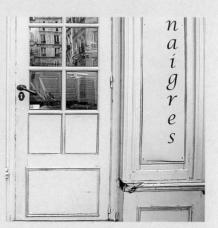

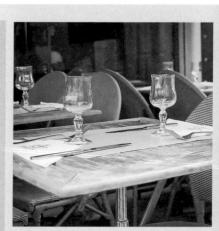

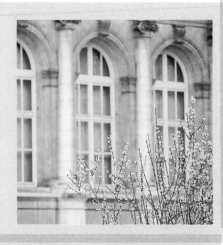
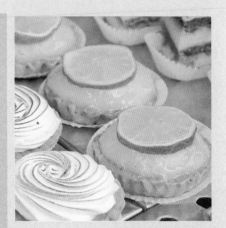

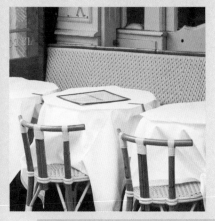

JAUNE

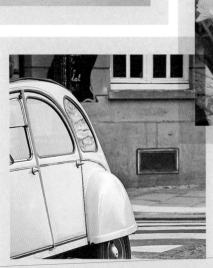
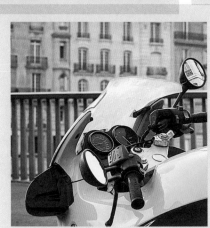

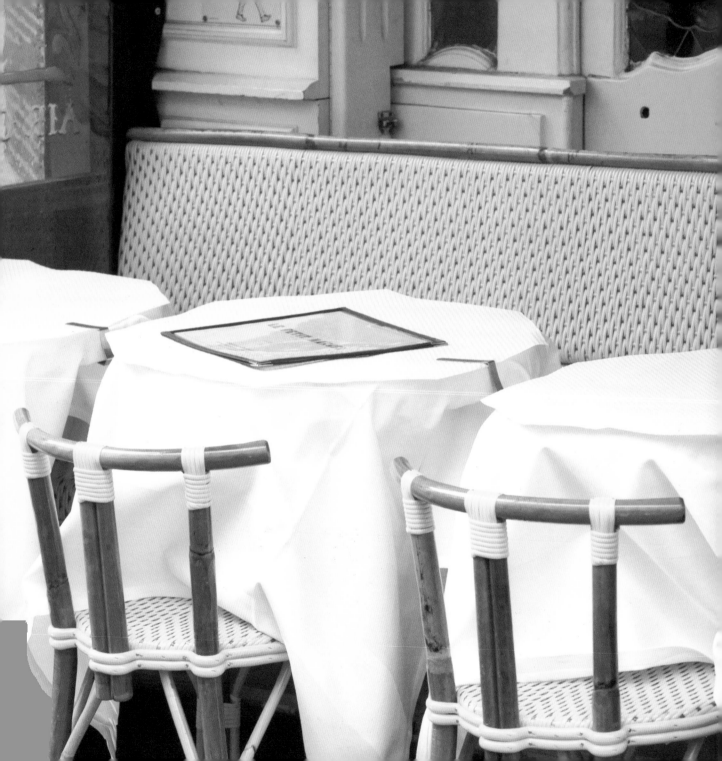

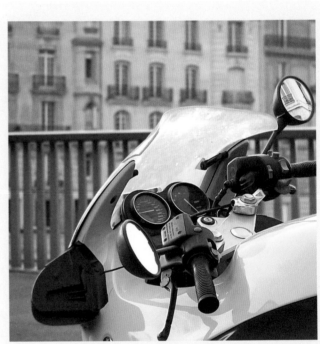

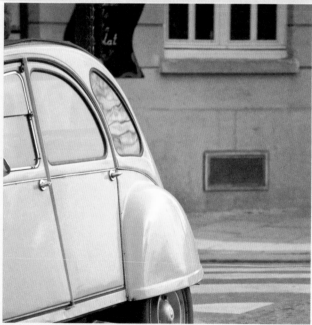

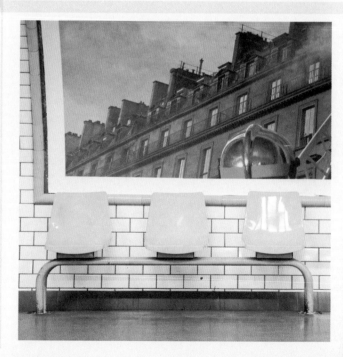

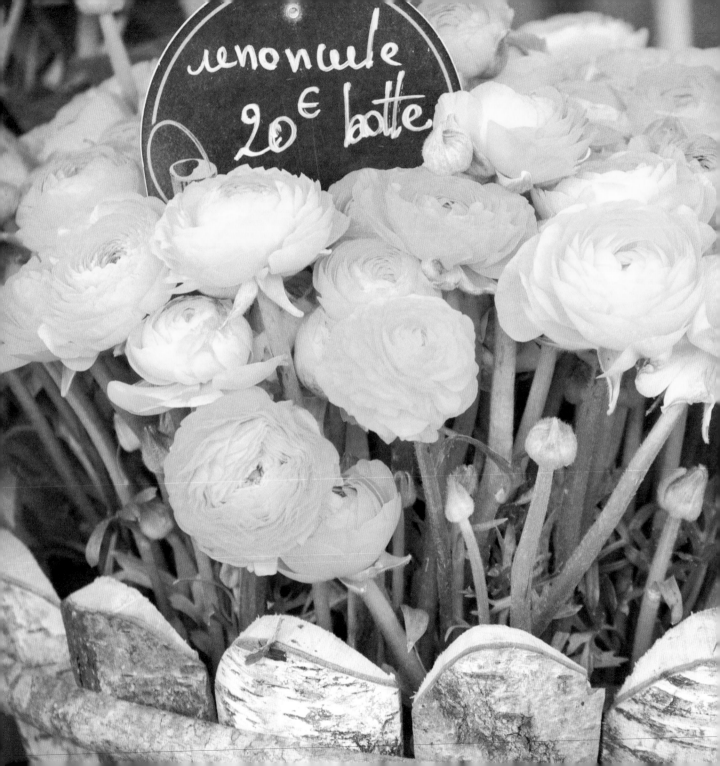

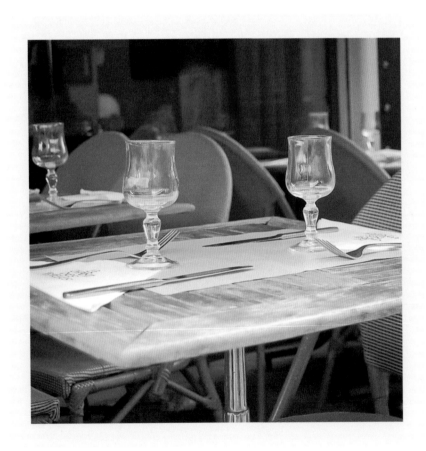